MR WAFFLES LOVES DESIGN

BY LISA S. ROBERTS

Published 2019

Printed in the United States of America
Print ISBN: 978-0-578-46483-1
Library of Congress Control Number: 2019902513

Publisher Information:
Canoe Tree Press
PO Box 867
Manchester, VT 05254

Canoe Tree Press is an imprint of DartFrog Books
www.DartFrogBooks.com

INTRODUCTION

Meet Mr. Waffles. At four months, he was adopted from a shelter, and now lives with a family who collects contemporary design. Their house is filled with really cool stuff, and Mr. Waffles explores it all. Climbing on furniture, scratching on table legs, knocking over lamps, sniffing trashcans and toilet brushes—nothing escapes his curiosity. What his owners soon came to realize was ...

MR WAFFLES LOVES DESIGN!

Toilet brushes have become a badge of honor, maybe an obsession

for many designers. **Merdolino**, created by **Stefano Giovannoni**, resembles a leafless potted plant. This whimsical design removes any stigma or preconceived notion about a toilet cleaner. So what's the connection to its function? Nothing! That's the point! It remains a mystery until the handle is pulled from the pot.

I wouldn't do that Mr. Waffles.

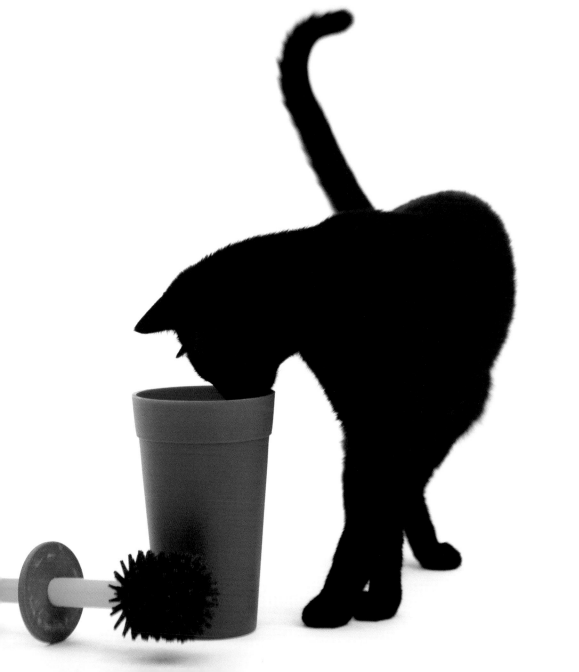

7

Patricia Urquiola is known for using dynamic colors and surprising materials in her designs. The **Antibodi** chair incorporates both.

She transforms the traditional material of felted wool into a magnificent bed of colorful flowers. The first instinct is to sit carefully for fear of crushing the blossoms, but Urquiola understands that wool is a resilient and crushable material that can cushion the body, **aptly demonstrated by Mr. Waffles.**

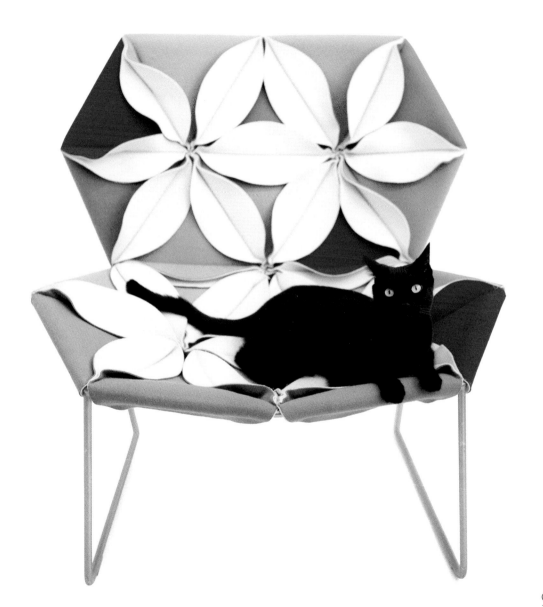

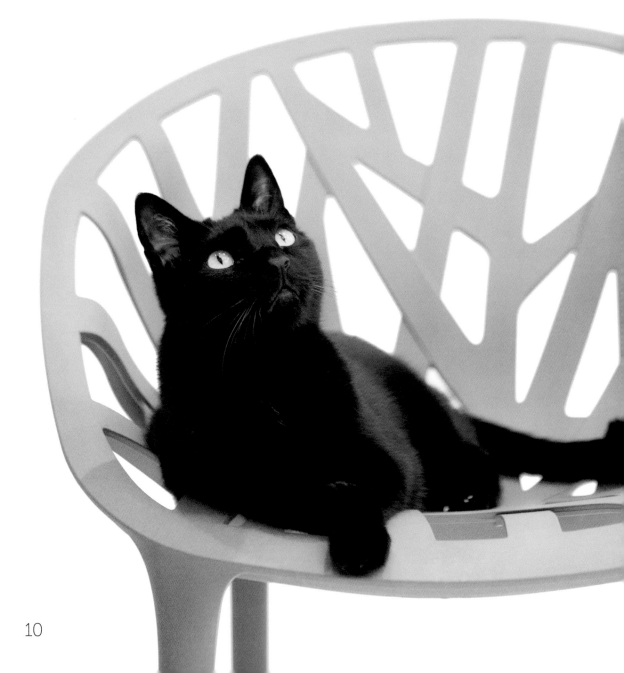

The Bouroullec brothers

were inspired

to design **Vegetal** after they learned about a 19th-century technique, where young trees were trained over many years to take on the shape of a chair. As it turned out, it took the designers nearly as long to figure out how to mass-produce this complicated design. Recreating nature's asymmetry was more difficult than the designers and manufacturer ever expected. The first prototype used round pieces that mimicked branches, but this was not very comfortable, so they flattened the branches, 'pruned' the quantity, and after four years start-to-finish, their chair was produced. Mr. Waffles applauds their persistence.

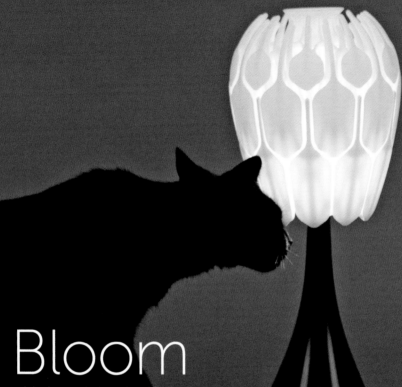

Bloom

table lamp is inspired by a flower blossom. At first, it resembles a closed bud, but then opens to reveal its inner beauty and intricacy. The gesture of pressing down on the top of the shade is what transforms it from bud to blossom. This is what **Patrick Jouin** had in mind when he said he "designs the gesture."

"Voilà!"

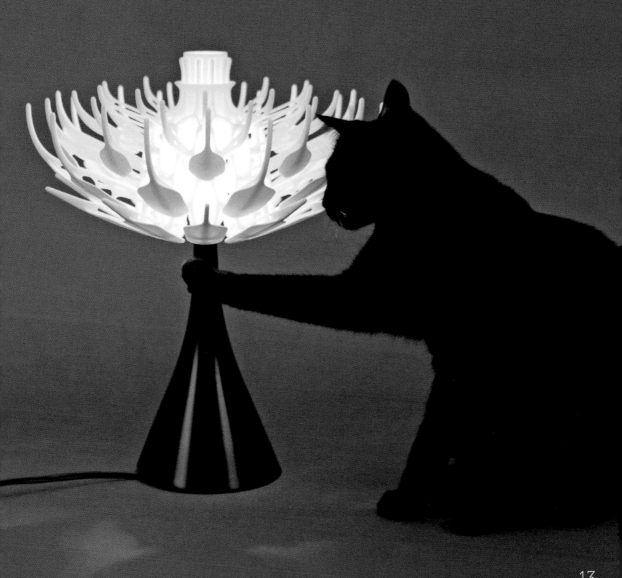

Algues
(French for "algae")

Algues comes as a set of identical plastic pieces. There are 19 different points where the pieces can connect to each other with pegs. Once they are assembled, no two designs are alike. They can be configured into a screen, wall hanging or even a room divider.

Mr. Waffles assesses the placement of each and every one.

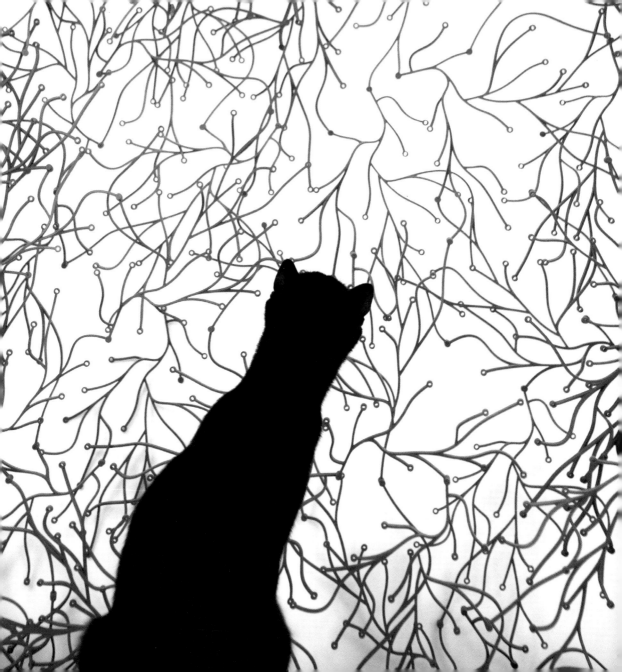

Ron Arad's flexible bookshelf

is a strip of plastic that can be shaped into a circular spiral, a wiggly worm, or just about anything sinuous. The more bends and curves in the configuration, the more weight the shelf can handle. **Bookworm** does have its limitations—it cannot be bent into right angles or go in a straight line.

"I only see design books, anything on cats?"

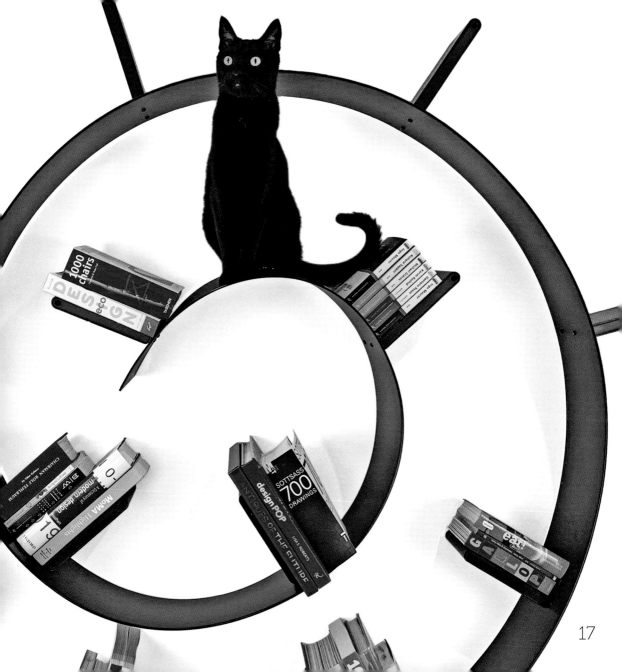

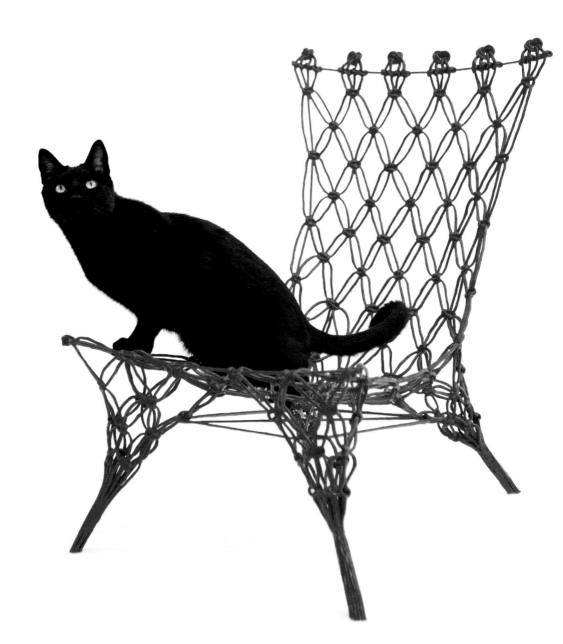

The Knotted Chair by
Marcel Wanders

is reminiscent of the macramé plant holders popular in the 1970s. However, this rope is embedded with carbon fiber, making it exceptionally strong. The rope is knotted into the shape of a chair, draped over a frame, and then infused with epoxy resin. When the resin dries, the textile hardens into its shape and has both strength and rigidity. What's amazing about the chair is it weighs less than 3 pounds and can support up to 170 pounds.

Mr. Waffles looks a bit nervous and wonders how much do I weigh?

Carbon fibers are a bit like cats:

they're strong, flexible and lightweight. Like his earlier Knotted Chair, **Marcel Wanders** continued to explore the use of this material in his collaboration with Bertjan Pot on the **Carbon Chair**. The carbon fiber is dipped in epoxy resin to stabilize it and then, hand-coiled around a mold in a seemingly random pattern. Though it may look nonchalant, the placement is strategic. The fibers are wrapped more loosely on the back and more densely on the seat, making the chair both lightweight and strong.

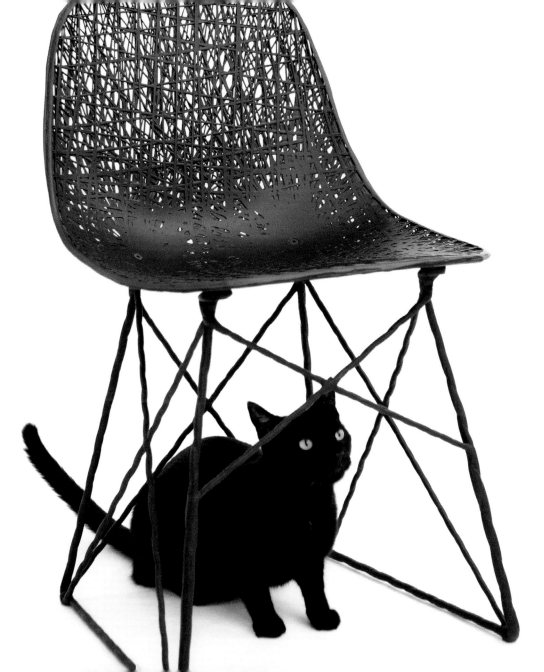

21

Natalie Kruch
tried and rejected

raffia, leather, different types of fabric, and even elastic bands before landing on balloons for her playful stool **Balloona**. More than five hundred pink, orange, yellow, red, and green, and purple balloons were tied by hand to a solid wood stool to create this festive seat. Unfortunately, the stool is not **cat-proof**.

23

Karim Rashid

has transformed every aspect of the classic **chess set** using his personal "Blobular" design vocabulary. The sensual and biomorphic pieces are soft and rubbery to the touch, adding a tactile experience to playing the game. The board fore-goes the traditional checkerboard squares, and instead features colored circles that align perfectly with the base of the chess pieces. Most conveniently, the board is also an acrylic box that slides open to store the pieces when not in use.

Your move, Mr. Waffles.

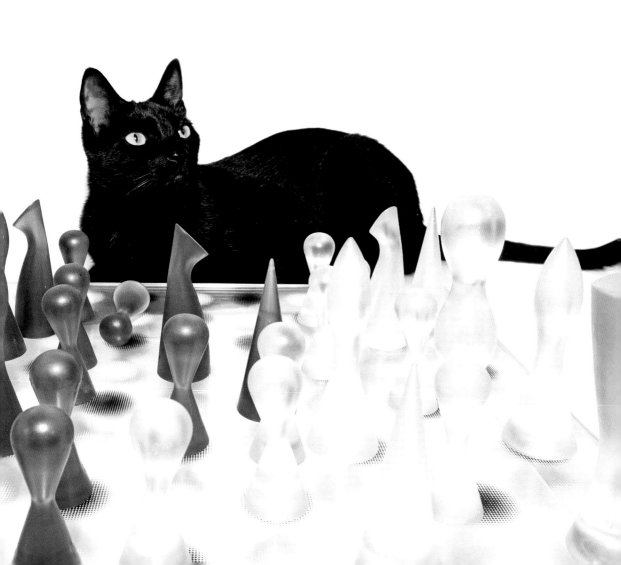

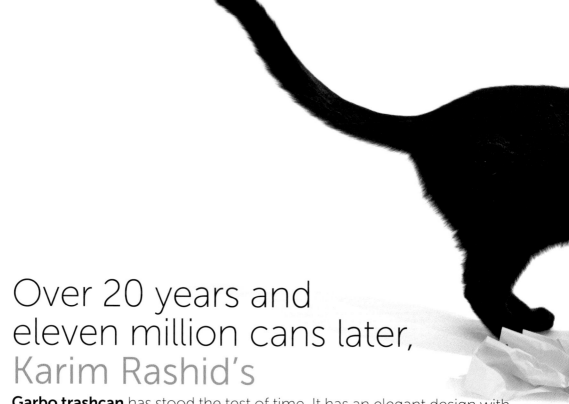

Over 20 years and eleven million cans later, Karim Rashid's

Garbo trashcan has stood the test of time. It has an elegant design with **a distinctively feminine persona, and it's most appealing to male cats.** It is also practical. The handles are cut out of the upper sides so it's easy to avoid touching the trash while emptying it, and the inside bottom is rounded making it a snap to clean. The success of Garbo not only put the designer Karim Rashid on the map, but it also put his can into the permanent collection of the Museum of Modern Art!

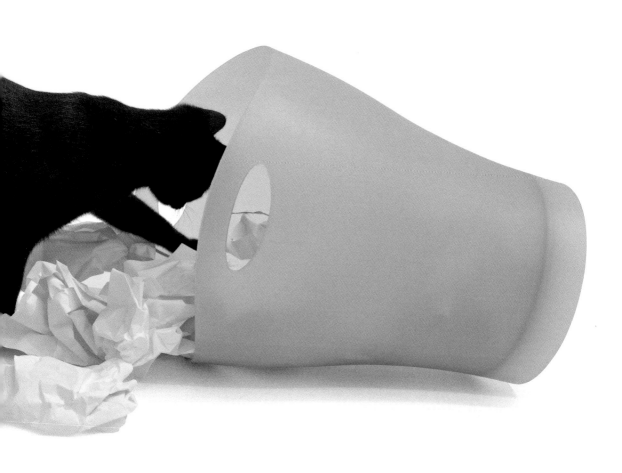

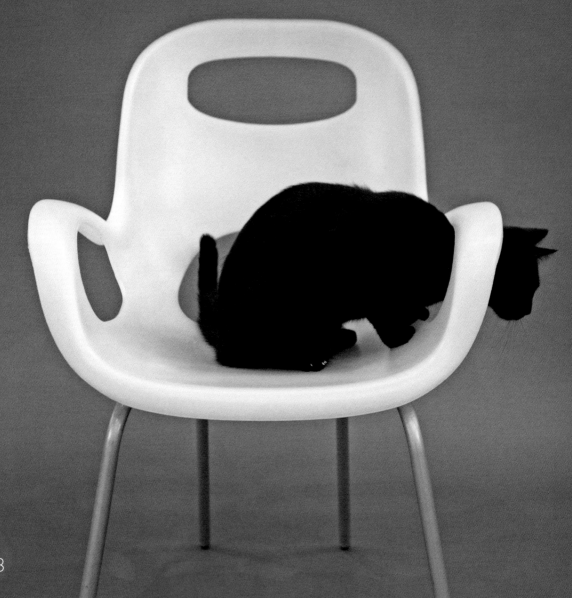

Following Karim Rashid's extremely successful Garbo wastebasket, he created Oh Chair.

It shares many of the design elements of the wastebaskets—rounded curves, cutouts, and the same plastic material. The cutouts might seem to weaken the chair but they are strategically placed and so they do not jeopardize the chair's strength. It can hold up to 300 pounds. The chair was also designed to be affordable to just about anyone. At $40, 50,000 of them sold in their first three weeks on the market.

"Anybody down there?"

First Chair

is the most popular product from the short-lived Memphis design movement in the 1980s. It was quite unusual for its time, with balls for armrests and circular disks for the seat and back. Most of the designs from this era were too revolutionary for the market and stopped production within a few years. The First Chair, however, stood the test of time. It sold so well, it has been continuously produced for more than 35 years.

"Yes, the universe revolves around me."

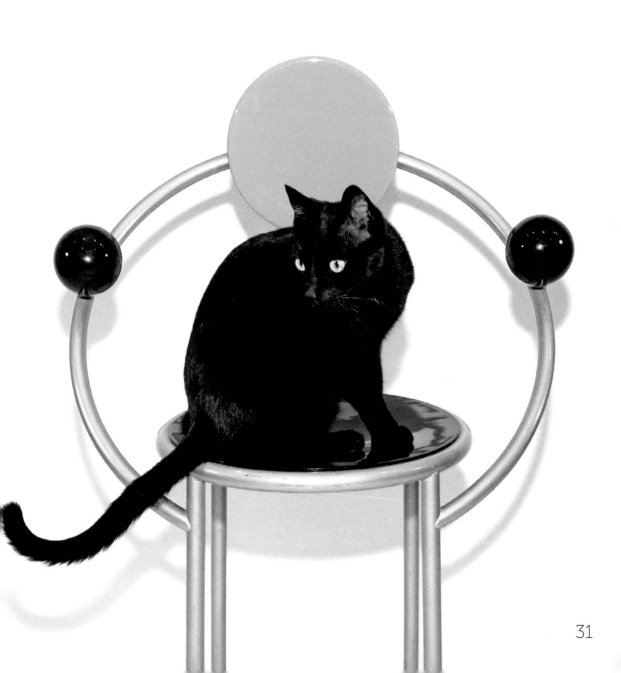

French designer Cedric Ragot

has captured 500 years of history with the design of his **Fast Vase**. One side, the "quiet" side, pays homage to ancient Chinese Ming vases. The "fast" side is abstract and futuristic, based on a digital image of acceleration. **Mr. Waffles waits in anticipation for the vase to take off.**

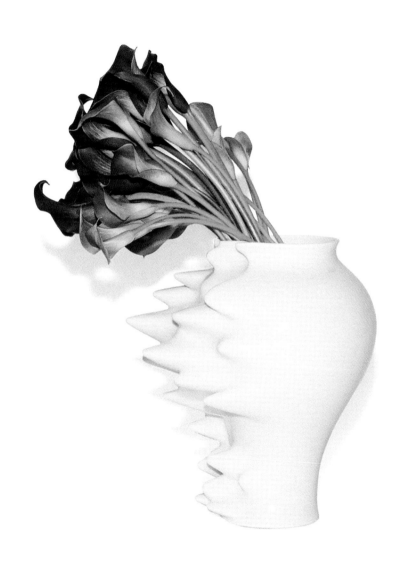

Issey Miyake,

the renowned fashion designer, experiments with new technologies and unusual materials. Working with the lighting company Artemide, he created a transformational series of lamps that are packed and shipped flat, and then pop up into 3D origami shapes. The **Mendori** lamps are self-supporting with no internal structure. The designers used mathematical calculations to design the folds of the plasticized 'paper' which is made of recycled PET bottles.

"Did it just move?"

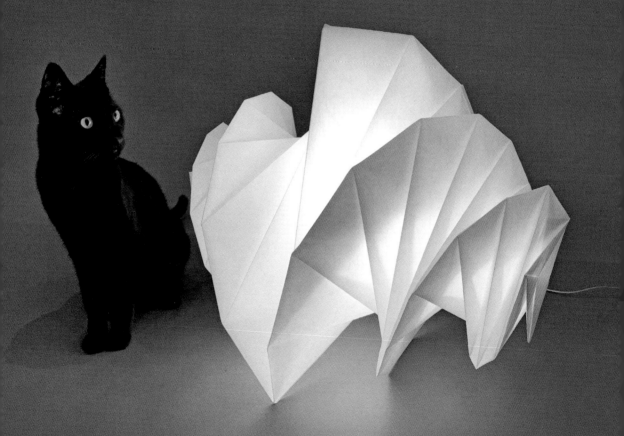

Philippe Starck

transformed a utilitarian colander into an 'object d'art.' He incorporated luxury materials (along with a luxurious price), decorated the surface, and aggrandized its size. But **Max Le Chinois** is also quite practical. Unlike other colanders, it comes with a plastic liner that can be used as a vase, fruit bowl, ice bucket, or for a potted plant. In fact, it's so stylish, it looks good just sitting on the counter doing nothing at all.

"HELLOOOOOOOO?"

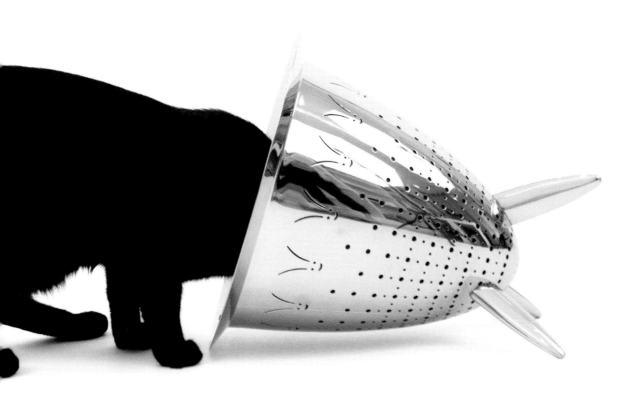

Moon Chair was inspired by the glowing luminescence and ephemeral qualities of the moon.

Using a translucent plastic, Tokujin Yoshioka's design alters one's perception of the material. It seems to change density from the backrest to the seat to its base. Its softly rounded curves make it an extremely comfortable chair, and **a perfect nestling place for Mr. Waffles**.

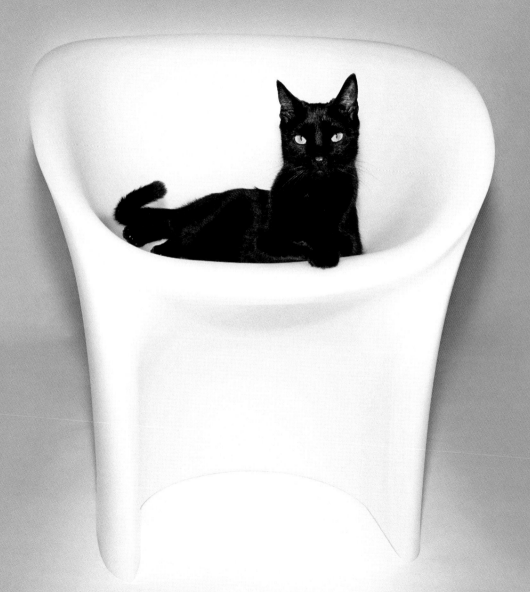

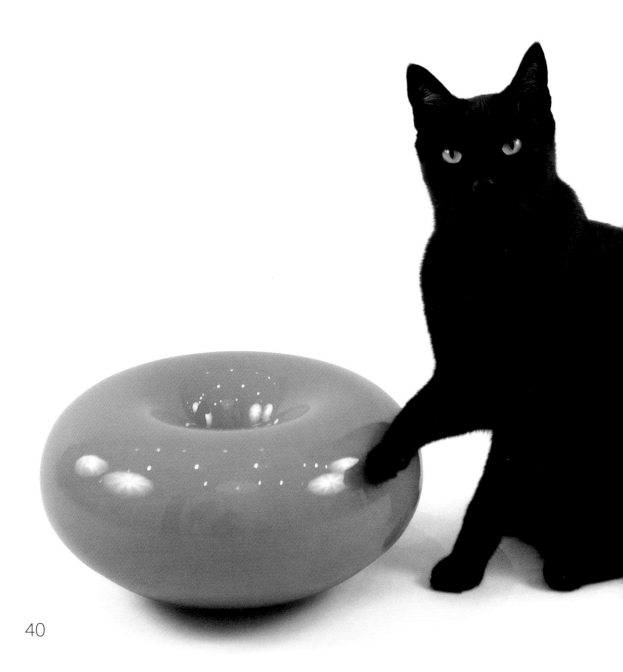

Japanese designer Naoto Fukasawa

approaches design as a thoughtful minimalist—he strives to get the most functionality from the fewest possible parts. He also endows his designs with subtle references, hinting at what the piece is really about. When you first look at his **Plus Minus Zero** Humidifier, it may look like a simple doughnut. In fact, it's much more poetic. Inspiration came from a drop of water as it hits the surface and begins to ripple. But how does it work? The 'doughnut' splits apart and inside is a flawlessly designed, functional humidifier.

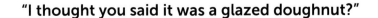

"I thought you said it was a glazed doughnut?"

Dirk Vander Kooij repurposed an out-of-work robot and made it into a 3D printer.

Using an extrusion method, like squeezing toothpaste from a tube, he programmed the printer to build the chair layer-by-layer with a very unusual material—white plastic refrigerators. He broke up the plastic, melted it down, and infused it with colors. Each **Chubby Chair** takes only a few hours to make—much faster than other 3D printing methods—and significantly cheaper at $500 rather than thousands of dollars.

"Refrigerators, really?"

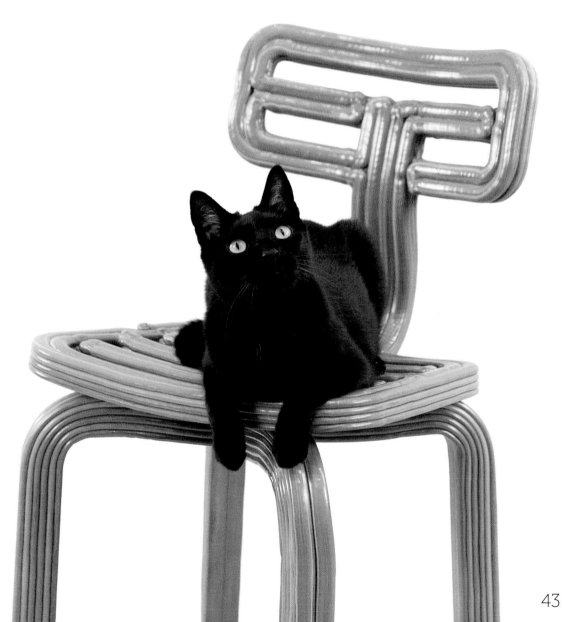

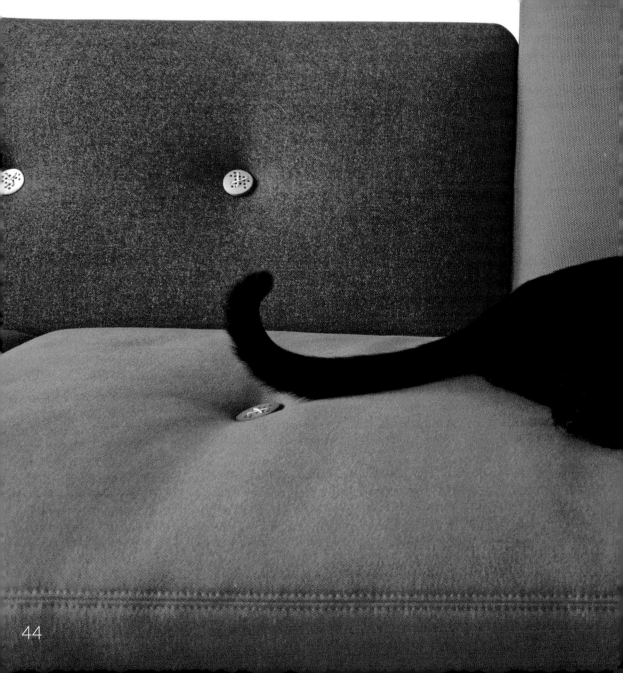

Polders are patches of low-lying land commonly found in the Netherlands.

They create a mosaic pattern of color and texture in the landscape, and this became the inspiration for **Dutch designer Hella Jongerius' Polder** sofa. Her couch incorporates six different fabrics and colors on six different components. All of the colors are a variation of the same hue, reinforcing how the polders look in the landscape. Jongerius is also known for incorporating handcraft into her designs. She does this with the oversized buttons made of bone, shell and wood. They are fastened on tightly, although **Mr. Waffles has done his level best to remove them.**

Sandy Chilewich

co-founded HUE, the women's fashion hosiery company, in 1978.

She pioneered the use of Lycra, a spandex material with natural fibers, for a new style of legwear. After great success, she sold the company and opened a design studio which focused on making products out of non-traditional materials. The three-tiered **RayTRAY** was one of her first designs. They were made with the same stretch fabric she used with the pantyhose and girdles in her former company. The material is wrapped around a metal frame that stretches when objects are placed inside. One nice benefit of the mesh is that it allows fruits and vegetables to breathe.

"Three servings of fruit? I think I'll pass."

The unusual collaboration between **Ron Arad,** architect and furniture designer, and the fashion house of **Issey Miyake** blurs the lines between furniture and fashion.

Arad's plastic **Ripple Chair** has been covered by Miyake's **Gemini,** a digitally manufactured textile that can function as chair cover or be removed and worn as a vest. The inventive textile was created with Miyake's engineer Dai Fujiwara and is known as APOC (A Piece of Cloth). It's a single piece of cloth without piecework or hand sewing. **Mr. Waffles strikes a pose, showing his good side.**

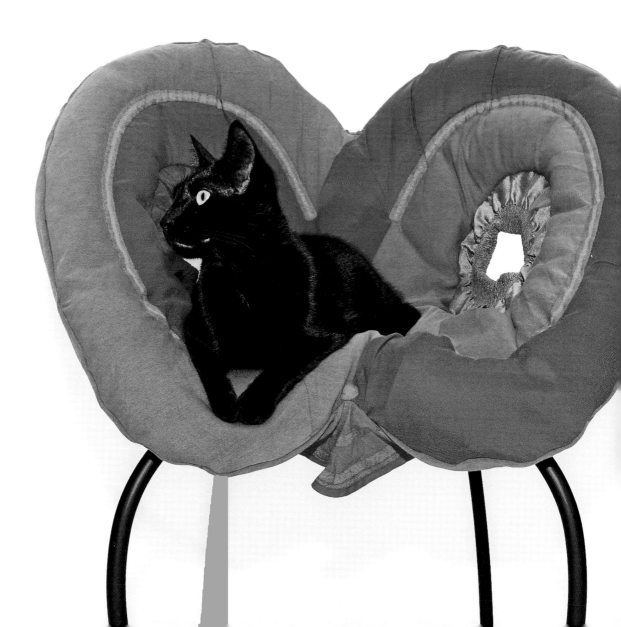

Many designers have attempted to re-design the classic toilet brush, but no one has done it with such whimsy and creepiness as Robin Platt & Cairn Young. **TOQ** features an eyeball halfway up its stem, giving one an eerie sense of being watched. Of course that's the idea—the toilet is the last place you want a one-eyed alien spying on you.

"What are you eyeing?"

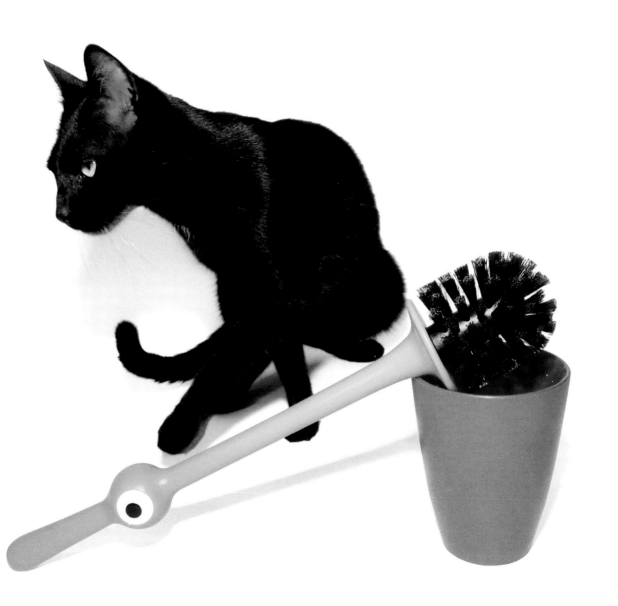

Tom Dixon
is a self-taught designer who never finished art school.

One of the skills he taught himself was to weld, mostly for the practical purpose of fixing his motorcycles. He used this skill in the making of the **S-Chair**. The idea for the chair sprang from a doodle of a chicken. Dixon made 50 prototypes before settling on his final version, an elegant and sinewy design that was all spine and no legs. The chair was made of bent steel and covered with a variety of materials. This one is made of woven marsh straw and is reminiscent of the traditional comfortable wicker chair.

Hypnotized by the undulating curves.

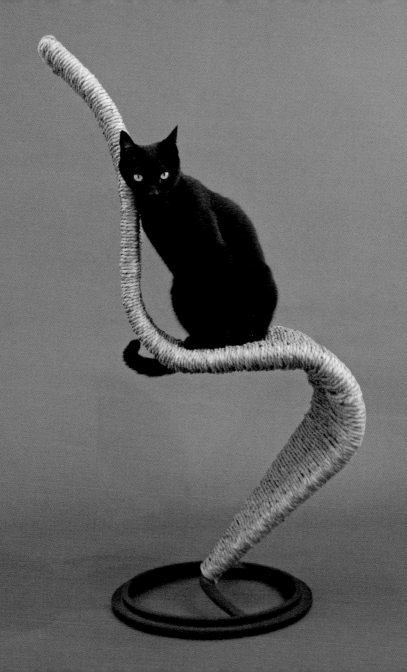

Designers often look to reality for inspiration. **Harry Allen** went one step further using a real piglet to mold the shape of **Pig Bank**. (Allen is quick to point out that no animal was harmed in the process—the pig had already died of natural causes.) A taxidermist then stuffed the piglet. From there, the designer had a museum-quality cast made using resin and marble dust. These materials gave it heft and articulated detailing so that every hair and wrinkle was defined. Allen then added an oversized cork to its underbelly so there would be no confusion this was a bank.

Give up Mr. Waffles,
you can't win this staring contest.

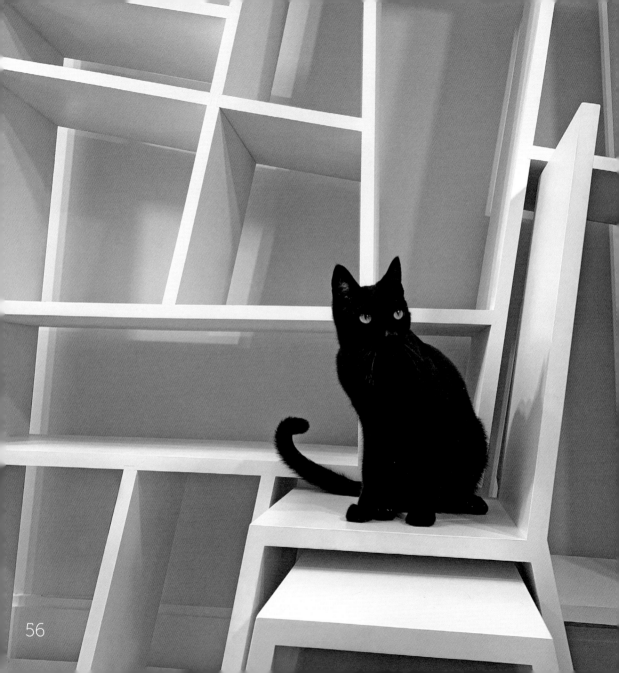

Australian designer Charles Trevelyan

recognized that when people browse through a bookshelf, they often want to sit down right there and read a book—**Shelflife** provides this opportunity. A chair and table are fully integrated within the bookcase and can easily be pulled out and set-up like a study. More than just a place to put books, Trevelyan has created a three-dimensional abstract 'painting.' With strong, graphic impact and complex geometry, it is as interesting with books as without. **For Mr. Waffles, it's a place to ponder the big question: what's for lunch?**

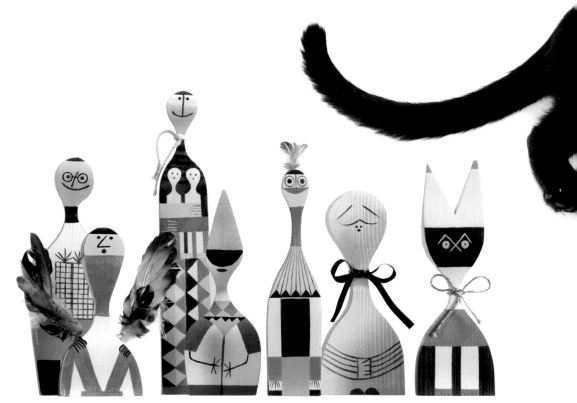

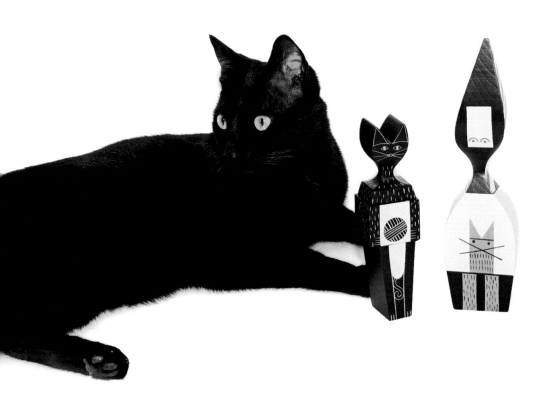

Alexander Girard was a postwar designer most well known for his vibrant textiles. He also designed furniture, interiors and even toys. Inspired by the folk arts of Central America and Europe, he created a series of wooden dolls and animals to decorate his home in Santa Fe. **Vitra** saw the commercial value of the dolls and recreated them for production, almost exactly like the originals, even down to their hand painting. **No surprise— of all the dolls, Mr. Waffles liked the cats best.**

Burning furniture

may seem like an act of destruction, but for Dutch designer **Maarten Baas**, this concept blossomed into an act of creation. He challenged notions of beauty and perfection when he set a torch to furniture with his **Smoke Dining Chair**. However, before the chair totally disintegrated, he infused the remaining ashes with resin. Once it dried, it solidified into a hard plastic. To create a contrast from the rustic appearance of the frame, he covered the seat with smooth leather upholstery.

Don't look so worried Mr. Waffles, it wasn't your fault.

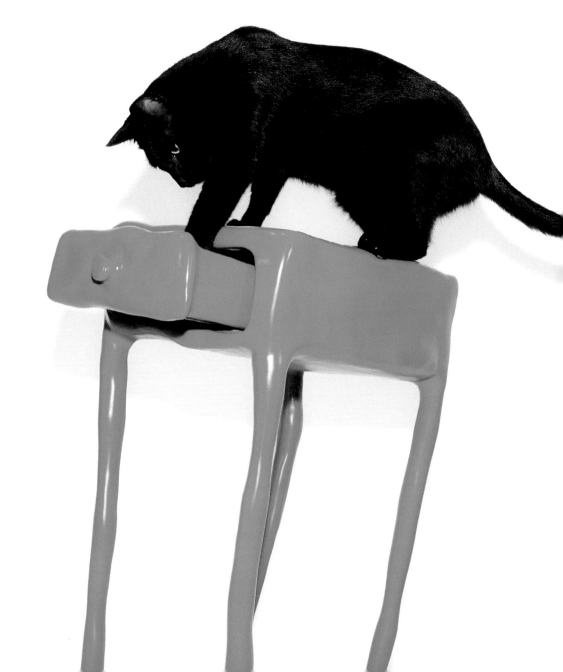

At first glance,
Clay Furniture by Maarten Baas

looks unstable when in fact, it's just the opposite. The root of this paradox lies in its construction. Beneath the exterior hand-molded clay, there is a steel skeleton. The frame has been intentionally designed to look irregular and wobbly, but it is structurally sound. Maarten Baas likes to play with the viewer, reminding them that first impressions can be deceiving.

"Did I hide some snacks in here?"

In an expression of minimalism, Oki Sato

of Nendo has created just the barest outline of a chair. A single rod begins as the left front leg, curves around to become the armrest, morphs into the backrest, and descends to the floor as the back leg. The chair, titled **Softer than Steel**, defies the properties of steel with its bends and curves—**demonstrated by Mr. Waffles with his chair imitation.**

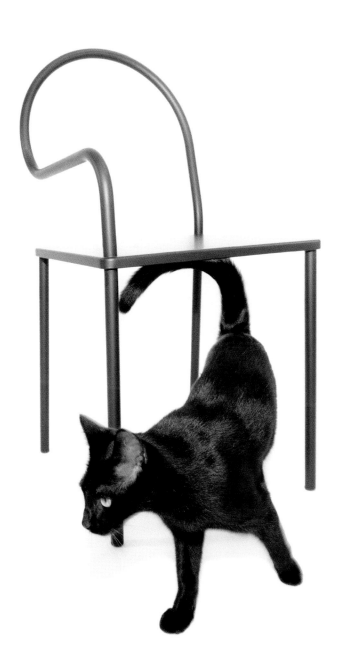

New York designer Stephen Burks traveled to Cape Town,

South Africa to work with local artisans using their indigenous materials and crafting skills. Together, they worked as a team to create the **Love Bowl** series using liquid silicone rubber and glass tiles. When the silicone dried, the final bowl was soft and flexible with a surface resembling stained glass.

Mr. Waffles inspects the Love Bowl for some treats.

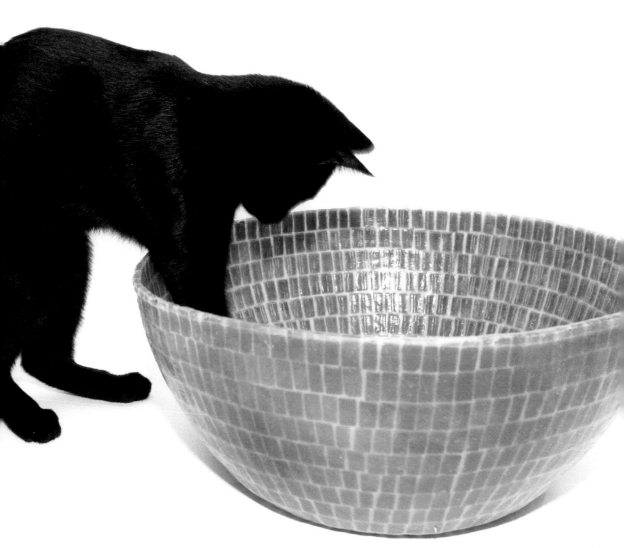

Wooden Chair

Wooden Chair resembles the skeletal structure of a boat. It's made of bentwood slats that increase in length toward the center, giving it a bow shape. To bend the wood, the strips are steam heated and wedged into a mold. Once dry, they are screwed to cross supports to hold them in place. **Marc Newson's** Wooden Chair may look delicate, but it is quite sturdy.

Mr. Waffles relaxes below deck.

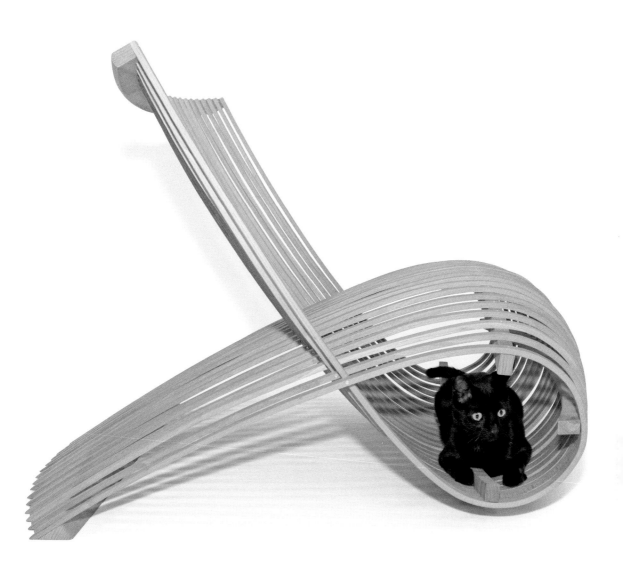

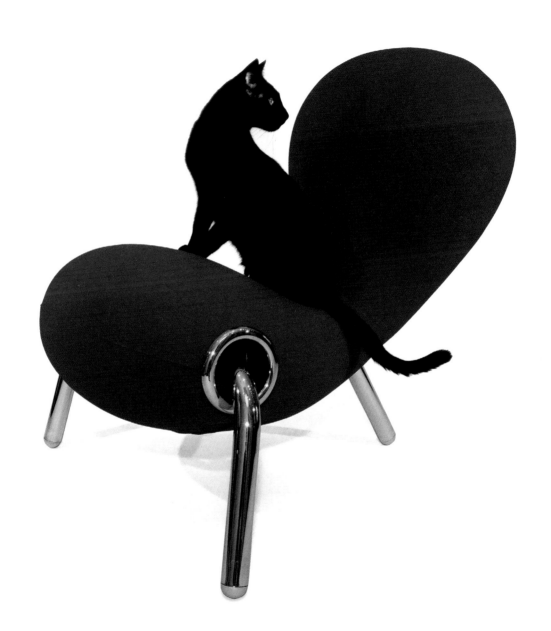

Growing up in the 1960s and 1970s,
Marc Newson loved watching "The Jetsons" cartoons.

He was greatly influenced by its space-age images of the future, and incorporated them into his own work. One of his early designs was the **Embryo Chair**. Seemingly 'hatched' from a cartoon, the chair's bulgy shape makes it a bit of a puzzle to sit on. Newson designed the chair using injection molding, a relatively new process at the time. Polyurethane foam was injected into a mold and then covered with fabric. Initially, they used neoprene, a wet suit material. Today, a more practical synthetic upholstery fabric is used. **The design may be challenging for most earthlings, but not for this space-age cat.**

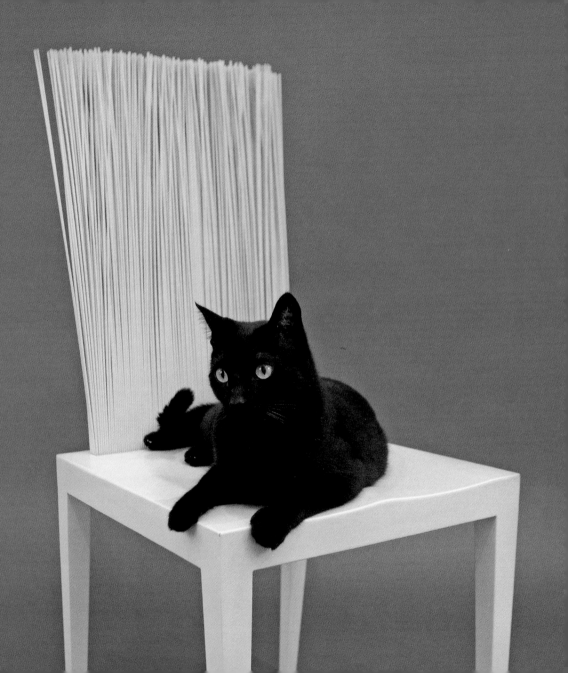

The Campanas designed their colorful chair in honor of a favorite client named **Jenette**.

Influenced by the broom sweepers back home in Brazil, they designed the back of the chair with 900 PVC rods. But how do these flexible bristles not bend over when someone leans back in the chair? Hidden within the rods, there is a steel bracket that provides comfortable support.

"This yellow is making me mellow."

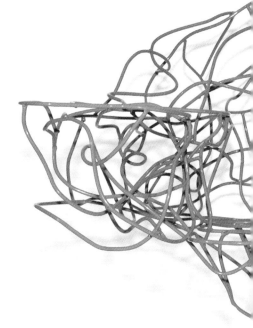

Corallo

means 'coral' and is one of the inspirations for the overall shape and color of this chair. But the idea for the Corallo chair also came from the attempt to freeze a scribble of lines in space. Each chair has its own personality, and is hand crafted so that no two are alike. **However, Umberto and Fernando Campana never envisioned their chair would become** Mr. Waffles' jungle gym.

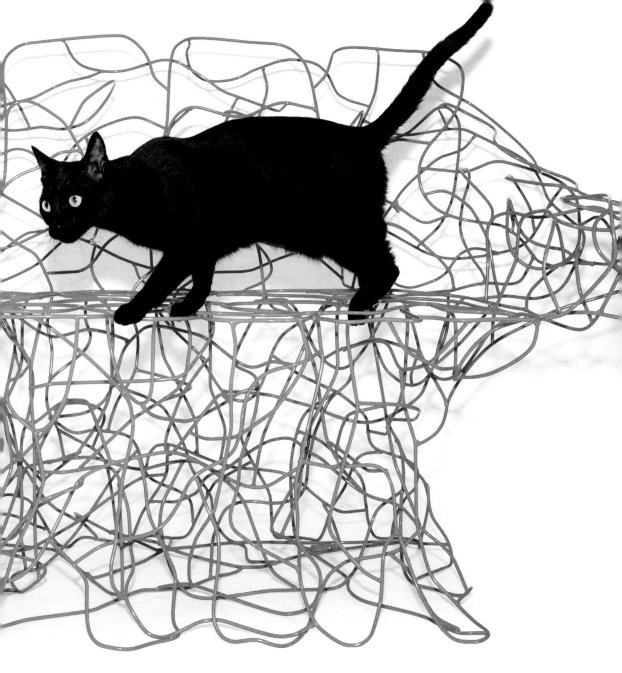

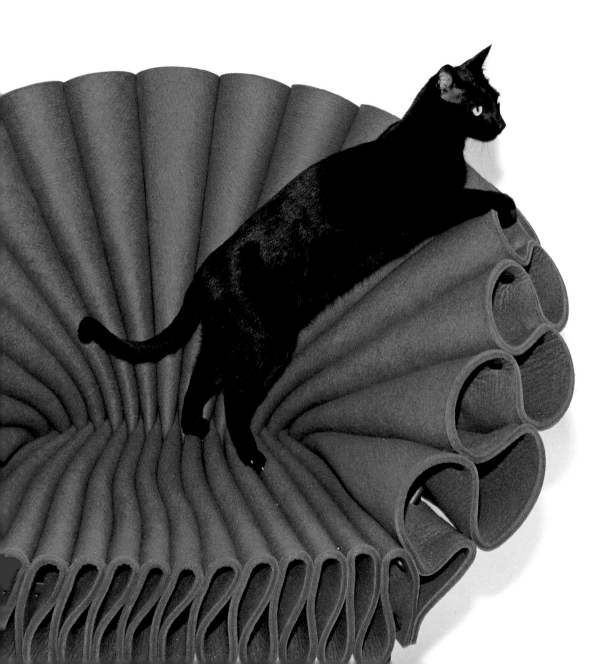

Dror Benshetrit interpreted the majestic spread of a peacock's feathers

with a pretty mundane material—industrial grade felt. He found that by folding it over and over, he could simulate the effect of plumage. To make this chair, it takes two people to fold three layers of this heavy material and then slide it onto a slender steel frame. Small rivets connect the top of the folds, but other than that, there are no additional screws or bolts that hold the chair together. The tightly compacted pleats are what provide the structure. The felt is a great cushioning material, making the **Peacock Armchair** very comfortable.

The peacock and the pussy cat, a perfect pair.

Joris Laarman demonstrated that high technology and handcraft could work together in the same design. He created a series of ten identically shaped chairs using different materials. Each chair is a puzzle of digitally fabricated parts that are hand assembled. One of the chairs in the series, **Polygon Chair**, is made of solid oak. Every piece is digitally carved from a block of wood using CNC milling, hand assembled and glued together. Although the chair consists entirely of flat triangles—**150 to be exact**—it curves gently into a very comfortable seat.

Steady, Mr. Waffles.

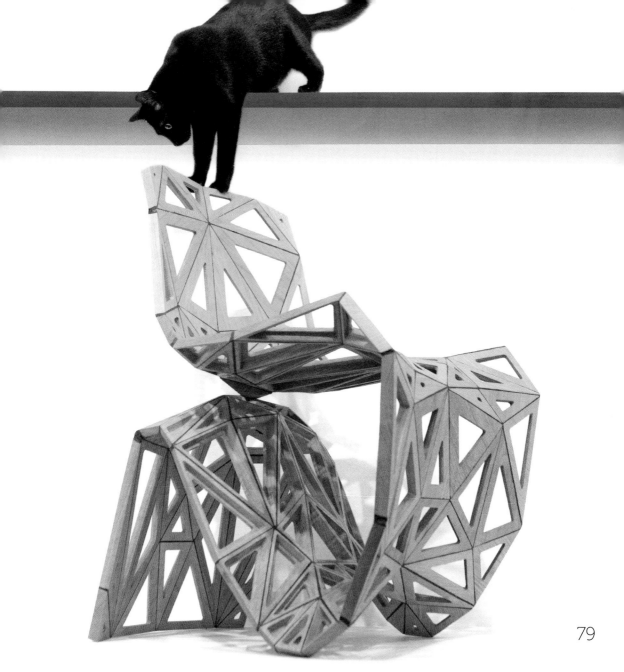

Ingo Maurer is a lighting designer, inventor and sculptor.

He has always been fascinated with the simple beauty of the naked light bulb. His **Lucellino** lamp is a single bulb that resembles a bird in flight. The custom-designed bulb, with handcrafted goose-feather wings, turns on and off incorporating a touch-tronic feature. Pinch the brass wire stem and the bulb goes on; pinch again and it goes off. The wires are low voltage so there is no danger of ever getting shocked.

"Hmmmm, what kind of bird is this?"

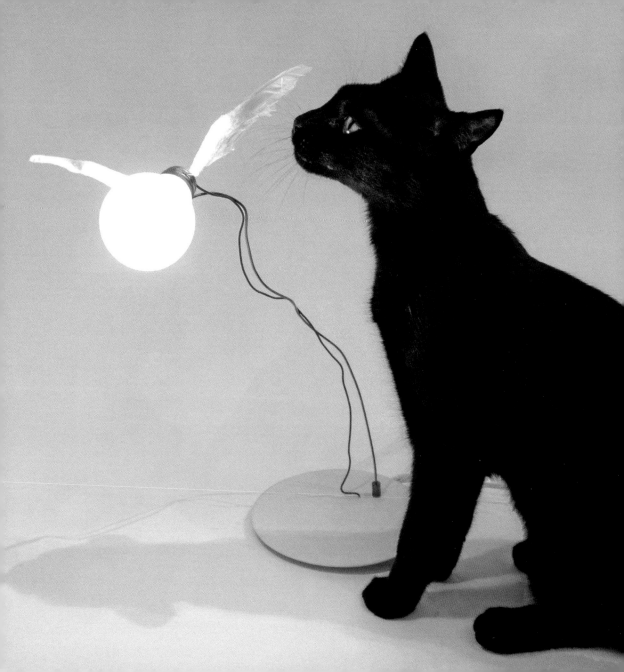

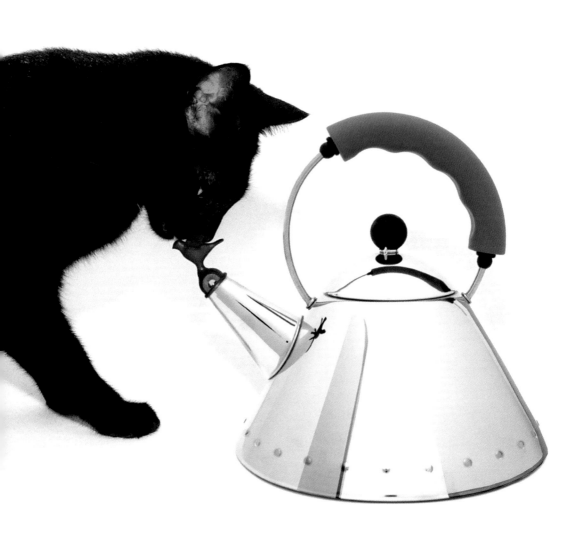

Possibly the most successful architect-designed product in history is the
Whistling Bird Tea Kettle by Michael Graves.
It debuted in 1985, and thirty years later, had sold more than two million kettles at an average price of $170.00. That's over 300 million dollars! Why does it remain such a hit? Everything about the kettle's design is thoughtful, from its broad base which allows a large amount of water to sit close to the stove's frame, to the cleverly designed ergonomic handle. The use of color is playful and intuitive: the blue handle signifies cool, and the red bird indicates heat and steam. **But it's the little bird whistle that makes the kettle completely irresistible, especially to Mr. Waffles.**

In the 1990s, Target

wanted to find a way to stand out among all the other mass-market stores. They chose architect **Michael Graves**, after his great success with the Whistling Bird Tea Kettle, to create an extensive housewares program. Over the next thirteen years, he designed hundreds of product including everything from cooking utensils and appliances to ironing boards and dustpans, clocks and telephones. Many of his designs incorporated his subtle humor and unique dusty colors of red, blue and yellow.

"Mr. Waffles here, who's calling please?"

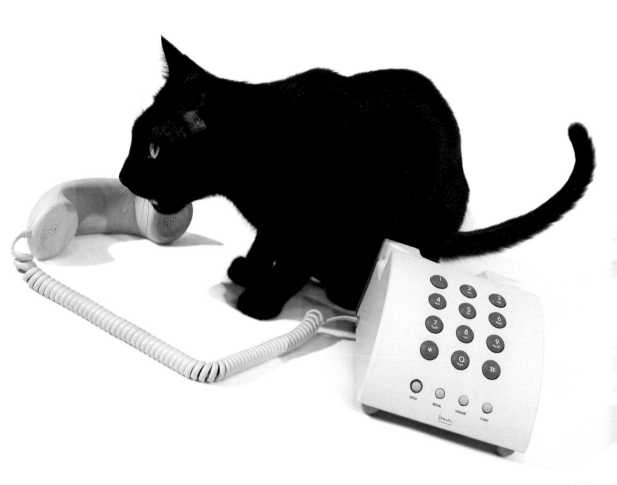

Renowned architect Frank Gehry

used conventional packaging material and transformed it into an elegant expression of design. **Wiggle Chair** has fifty-three layers of corrugated cardboard that are sandwiched together, making it structural. Fiberboard plates along the sides help protect the edges.

Best scratching post ever!

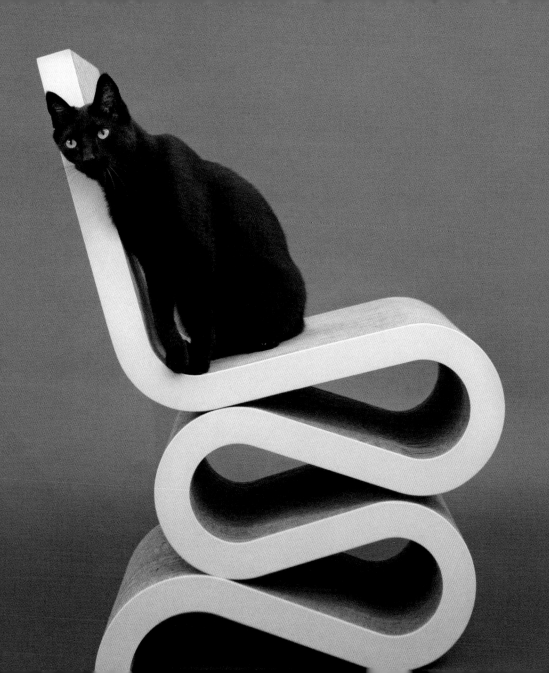

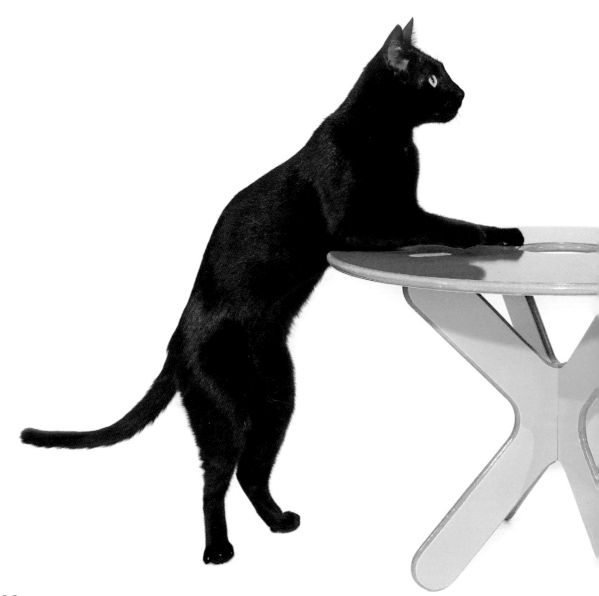

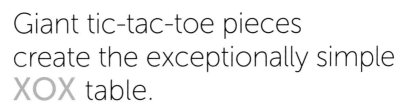

Giant tic-tac-toe pieces create the exceptionally simple XOX table.

Designer **Josh Owen's** table uses no glue or nails. The two **X's** slot together to form the base and the **O** sits on top, stabilized by four cutout slots.

Mr. Waffles wants in on this game.

People have said Zolo reminds them of Mr. Potato Head, but Mr. Potato Head is always a potato, always a mister and always a head. Zolo is whatever you imagine it to be, says designer Byron Glaser.

Mr. Waffles, on the other hand, is always a mister, always a cat, and always loves design.

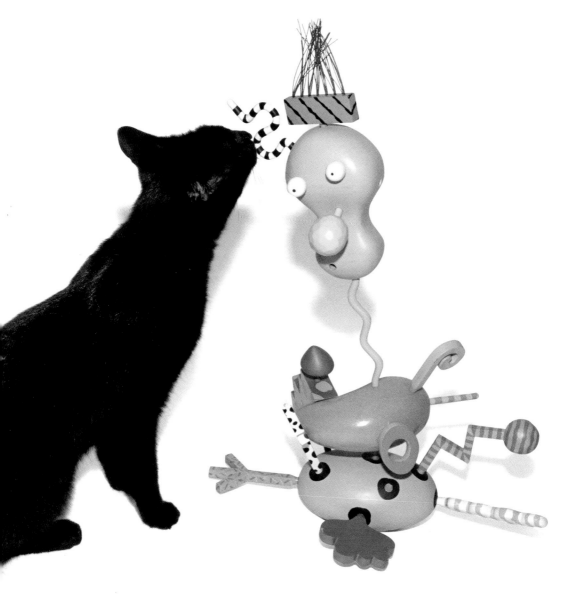

Index of Products

Algues
Designer: Ronan & Erwan Bouroullec
Manufacturer: Vitra
Date: 2004
Materials: injected polyamide

Antibodi
Designer: Patricia Urquiola
Manufacturer: Moroso
Date: 2006
Materials: stainless steel, felt

Balloona Stool
Designer: Natalie Kruch
Manufacturer: Umbra
Date: 2010
Materials: balloons, wood

Bank in the Shape of a Pig
Designer: Harry Allen
Manufacturer: Areaware
Date: 2004
Materials: cast polyester resin, cork, chrome finish

Bloom
Designer: Patrick Jouin
Manufacturer: MGX.Materialise
Date: 2010
Materials: SLS nylon, painted polyurethane

Bookworm
Designer: Ron Arad
Manufacturer: Kartell
Date: 1994
Materials: batch-dyed PVC

Carbon Chair
Designer: Bertjan Pot & Marcel Wanders
Manufacturer: Moooi
Date: 2004
Materials: carbon fiber & epoxy resin

Chess Set
Designer: Karim Rashid
Manufacturer: Bozart
Date: 2001
Materials: thermoplastic rubber, acrylic

Chubby Chair
Designer: Dirk Vander Kooij
Manufacturer: Studio Vander Kooij
Date: 2012
Materials: plastic (recycled from refrigerators)

Clay Table
Designer: Maarten Baas
Manufacturer: Baas & den Herder
Date: 2006
Materials: metal, industrial clay, painted with color lacquer

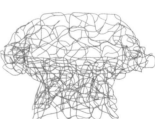

Corallo Chair
Designer: Humberto and Fernando Campana
Manufacturer: Edra
Date: 2004
Materials: steel wire, epoxy paint

Embryo Chair
Designer: Marc Newson
Manufacturer: Cappellini
Date: 1988
Materials: polyurethane foam,
synthetic upholstery fabric, aluminum

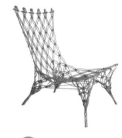

Fast Vase
Designer: Cedric Ragot
Manufacturer: Rosenthal
Date: 2007
Materials: porcelain

First Chair
Designer: Michele De Lucchi
Manufacturer: Memphis Milano
Date: 1983
Materials: wood, tubular steel

Garbo Can
Designer: Karim Rashid
Manufacturer: Umbra
Date: 1996
Materials: polypropylene

Jenette Chair
Designer: Humberto & Fernando Campana
Manufacturer: Edra
Date: designed 1999, manufactured 2004
Materials: polyurethane, steel core, PVC rods

IN-EI Mendori Lamp
Designer: Issey Miyake & Reality Lab
Manufacturer: Artemide
Date: 2012
Materials: PET, methacrylate,
aluminum, steel

Knotted Chair
Designer: Marcel Wanders for Droog Design
Manufacturer: Cappellini
Date: 1996
Materials: carbon and epoxy-coated aramid fibers

Love Bowl
Designer: Stephen Burks
Manufacturer: Cappellini
Date: 2005
Materials: glass tiles, silicone

Lucellino
Designer: Ingo Maurer
Manufacturer: Ingo Maurer
Date: 1992
Materials: glass, brass, plastic,
handcrafted goose-feather wings

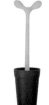

Max le Chinois
Designer: Philippe Starck
Manufacturer: Alessi
Date: 1990
Materials: stainless steel, brass

Merdolino
Designer: Stefano Giovannoni
Manufacturer: Alessi
Date: 1993
Materials: thermoplastic resin

Moon Chair
Designer: Tokujin Yoshioka
Manufacturer: Moroso
Date: 2010
Materials: 100% recyclable polyethylene

Oh Chair
Designer: Karim Rashid
Manufacturer: Umbra
Date: 1998
Materials: polypropylene,
powder-coated steel

Peacock Chair
Designer: Dror Benshetrit
Manufacturer: Cappellini
Date: 2009
Materials: felt, powder coated steel

Phone
Designer: Michael Graves
Manufacturer: Target
Date: 1999
Materials: plastic

Plus Minus Zero
Designer: Naoto Fukasawa
Manufacturer: plusminuszero (+ /- 0)
Date: 2003
Materials: polypropylene, polycarbonate

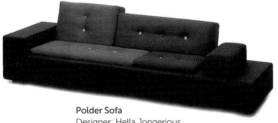

Polder Sofa
Designer: Hella Jongerious
Manufacturer: Vitra
Date: 2005
Materials: wooden frame, upholstery,
natural buttons

Polygon Chair/Maker Chair
Designer: Joris Laarman
Manufacturer: Joris Laarman Lab
Date: 2014
Materials: oak, epoxy

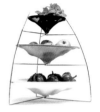

RayTRAY
Designer: Sandy Chilewich
Manufacturer: Chilewich
Date: 1998
Materials: Lycra, metal

Ripple A-POC Chair
Ripple Chair
Designer: Ron Arad
Manufacturer: Moroso
Date: 2005
Materials: polypropylene, steel

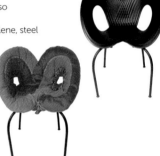

A-POC Gemini Vest
Designer: Issey Miyake & Dai Fujiwara
Manufacturer: A-POC
Date: 2006
Materials: wool, cotton, down

S-Chair
Designer: Tom Dixon
Manufacturer: Cappellini
Date: 1991
Materials: rush, steel

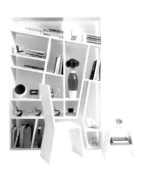

Shelflife
Designer: Charles Trevelyan
Manufacturer: Viable
Date: 2005
Materials: lacquered MDF

Smoke Dining Chair
Designer: Maarten Baas
Manufacturer: Moooi
Date: 2002
Materials: burnt wood, epoxy resin, leather

Softer Than Steel / 695
Designer: Nendo
Manufacturer: Desalto
Date: 2014
Materials: steel tube frame and lacquered aluminum seat

Toq
Designer: Robin Platt & Cairn Young
Manufacturer: Koziol
Date: 2001
Materials: thermoplastic

Vegetal Chair
Designer: Ronan and Erwan Bouroullec
Manufacturer: Vitra
Date: 2009
Materials: polyamide

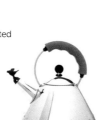

Vitra Dolls
Designer: Alexander Girard
Manufacturer: Vitra
Date: 1963
Materials: solid fir wood, hand-painted

Whistling Bird Tea Kettle
Designer: Michael Graves
Manufacturer: Alessi
Date: 1985
Materials: stainless steel, polyamide

Wiggle Chair
Designer: Frank Gehry
Manufacturer: Vitra
Date: 1972, 2005
Materials: corrugated cardboard, fiberboard

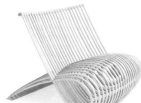

Wooden Chair
Designer: Marc Newson
Manufacturer: Cappellini
Date: 1988 (1992)
Materials: bent beech heartwood

Wrongwoods Credenza
Designers: Sebastian Wrong and Richard Woods
Manufacturer: Established & Sons
Date: 2007
Materials: plywood, chrome, wood

XOX Table
Designer: Josh Owen
Manufacturer: Casamania
Date: 2006
Materials: lacquered sheet fiberboard.

Zolo
Designer: Byron Glaser & Sandra Higashi
Manufacturer: Zolo
Date: 1986
Materials: wood

MR. WAFFLES
ALSO LOVES
Maria Eife, Lisa Benn,
Kelly Turso, Nate Ross,
Sarah Archer and
especially Evan Seltzer.

96